T0208317

ESPIONAGE OF THE LORD GOD ALMIGHTY JESUS HOLY SPIRITS AND WE THE PEOPLE

BRUCE CONNOLLY

authorHOUSE

AuthorHouse™
1663 Liberty Drive
Bloomington, IN 47403
www.authorhouse.com
Phone: 833-262-8899

Published by AuthorHouse 05/11/2023

ISBN: 979-8-8230-0819-8 (sc)
ISBN: 979-8-8230-0817-4 (hc)
ISBN: 979-8-8230-0818-1 (e)

Library of Congress Control Number: 2023908886

Print information available on the last page.

Contents

Chapter 1 Espionage..1

Chapter 2 Universes ..9

Chapter 3 Call To Defend The Universes....................................15

Chapter 4 Vortex Of Protection...25

Chapter 5 Espionage Of The Earth And Universes31

Chapter 6 Thwarting The Espionage Of The Earth And
 Universes ...39

Chapter 7 Presenting The Vortex Of Protection For We
 The People ..43

ESPIONAGE

Chapter One

ESPIONAGE

This is the second book of enlightenment in a series of enlightenment books. The first book is the Dimension of the Mind, Body, Soul, Spirit, and Universe. It explores how the mind, body, soul, spirit, and universe each interact separately and with each other, how the terrorism of war brings a person, family, community, country and world out of harmony and balance and how peace and freedom can bring a person, family, community, country and world back into harmony and balance with these dimensions. The third book of enlightenment is about what life is in harmony and balance with Peace and Freedom, yet to be written.

This book is how the espionage of the Lord God Almighty, Jesus, Holy Spirits was done by targeting WE THE PEOPLE and the truth of the writings of the Lord God Almighty and Jesus to use intelligence to break the Lord God Almighty and Jesus laws and rules with

fabricating lies and deceit by villainous war criminals of society for their power and control of society and make it sound like it's the right way to defend society, when in fact it is totally wrong, one hundred percent wrong. The preponderance of all people, all societies within governances, within countries, within worlds want to be defended for the truth of the Lord God Almighty and Jesus laws and rules, even in today's world from the lies and deceit and fabricated lies and deceit of the villainous war criminals of humanities assaults and lies and deceit breaking the Lord God Almighty and Jesus laws and rules. The Holy Spirits aid in developing the Lord God Almighty and Jesus laws and rules also help defend them.

How these espionage contacts lead to a villain's war assault or victimizers assault many violent on non-aggressors or lesser aggressors of society, known as the victims. The non-aggressors would be our general society and the lesser aggressors would be our peace officers and peace keeping forces.

The espionage villains war assaults are terroristic by these people of society and would be considered criminal to the people they are victimizing, the heartless acts, maybe of their country or between countries, possibly between worlds and even within galaxies and possibly between galaxies.

These criminals are considered the villains of the rest of society at a variety of levels. At a low level of an aggressive assault, the criminals impact a lesser number in society. At a high level like the military of a government, the war criminal villains impact both a lesser number and a greater number in society in possibly a more violent way in **psychological warfare and/or physical warfare.** Even at a lesser number, the criminal impact can be horrendous heinous crimes of humanity.

Basically, these Nazi war villain criminals, Devils and Humans

treat the Lord God Almighty, Jesus, Holy Spirits, the Manowar and Beast, and We The People as the villains and war villains of humanity with their espionage, lies and deceit and victimize all of us. By treating the Lord God Almighty, Jesus, Holy Spirits, and Manowar and Beast as villains, when they are not villains at all, and treat the We The People as villains, when we are probably not at all villains, and we all get victimized unjustly, they instantaneously become the Devil and/or Human criminal war villains themselves, the same difference as a devil. The illegal victimizations will be described throughout this book on the innocent, We The People for **NO** Justification what so ever.

These Nazi terroristic assaults would be considered heinous crimes psychological warfare and/or physical warfare such as slavery, mental slavery, torture, mental torture, physical maiming and even murder of suspecting victims and unsuspecting victims. Destruction of both human life and physical objects. They use fear as one of their primary assault weapons. Like other heinous crimes, these would be an espionage terroristic assault of the Lord God Almighty, Jesus and Holy Spirits as well, by breaking the Lord God Almighty and Jesus laws and rules. They target militaries of other countries, worlds and galaxies as well as target civilians in other countries, worlds and galaxies with villainous assaults. Often the corrupt Nazi part of a country target their own military and own civilians in villainous war assaults. These could be considered a civil war within a country. Between countries, this aggression could blossom from a small war into a world war. These are all cowardice, dishonorable and deplorable acts of humanity. Nazism within a country is considered traitor and treasonous criminal acts of war within a country, outside of a country these are similar traitor and treasonous acts of war to humanity (We The People). Devils have no shame for these deplorable war criminal

3

assaults of humanity, humans should be shameful, otherwise they are no different than a Devil.

People or countries or worlds continuing these war crimes could be considered criminal addicts and/or heinous criminal addicts of humanity. These could be the Devils of humanity or the same difference of human beings aggressively victimizing other human beings, countries, worlds and even galaxies. Some heinous criminal armies may consider this Imperialism. When in fact it's Nazism. They raise a swastika for their government flag over their countries flag and put in the Devil they trust.

Covered in my enlightenment book Dimensions of the Mind, Body, Soul, Spirit, and Universe explains how these Devils of humanity and same difference of human beings terrorize humans, countries and worlds. They can do this with assault weapons, spacecraft, assault projectiles, assault chemicals, etc. and also mental weapons such as telepathic, physical and mental weapons such as telekinetic and subliminal messages.

A Devil has various mental telepathic and mental telepathic physical telekinetic powers within them. The same difference of a Devil that is a human being may use computer aided device(s) and peripheral devices for telepathic, telekinetic powers and subliminal messages to assault unsuspecting victims.

What makes a Devil or person that is Devil like? It is a person that disregards the good holy laws and rules of the Lord God Almighty, Jesus and Holy Spirits to assault or offend a person in a dark evil way. This assault could be of the mind, body, soul, spirit, and universe of a person in countless various terroristic ways. In smaller terms, they would be considered the bullies, the villains of the sandbox who ignore the laws and rules for their own financial gain, job and enjoyment to justify their villainous assault. The dark evil mean

people of humanity, these would be the predominate sinners of humanity. Some call this the Devils game, but its no game, it's an egregious offending war(s) of humanity. They may treat all humanity as game pieces, not human beings at all with human rights and entitlements that all should have in reality. There is no reason known to human kind to take **away** these human rights and entitlements within their countries or outside of their countries. The peacekeepers are the opposite of the bullies and/or villains, they stand up to them to defend the rest of humanity and themselves from the bullies and/ or the villains. They are the law and rule enforcers, required in all societies. In all likelihood no person, government, world or galaxy was a threat or a danger to assault the criminal war terrorist, the criminal war terrorists fabricate lies and deceit of threats and danger to all humanity to assault humanity illegally.

What does it take to defend the Lord God Almighty flock(s) from the terrorists of humanity, the Devils and Devils flock? It takes an alliance of defenders, military, military police, peace officers at all levels of society and first responders and supporting responders (clinic and hospital staff). It takes a strong government supporting ethics, morals and harmony and balance throughout the government with the people. It takes people in many professions, many vocations, with many volunteers to support the defense of the flock(s) health and wellbeing. Harmony and balance includes safety and what makes a person, family, community, country, world, galaxy and universe whole. It takes the Lord God Almighty, Jesus, the Holy Spirits, Saints, Angels and Arc-Angles (Michael and Gabriel etc.) to defend the Lord God Almighty flock(s) for harmony and balance. As the Lord God Almighty flock(s) it take an allegiance of WE THE PEOPLE to support the alliance of defenders and the government in this defense for the quest of a great resolve of Peace and Freedom.

The Lord God Almighty alliance would also include wizards and gnomes who use their powers of mental telepathy and telekinetic correctly to defend humans and each other from the dark evil of humanity, aid the Lord God Almighty flock(s). In addition, Gods who also have telekinetic powers and a certain amount of telepathic power available to them to defend each other and the Lord God Almighty flock(s) from the dark evil of humanity.

UNIVERSES

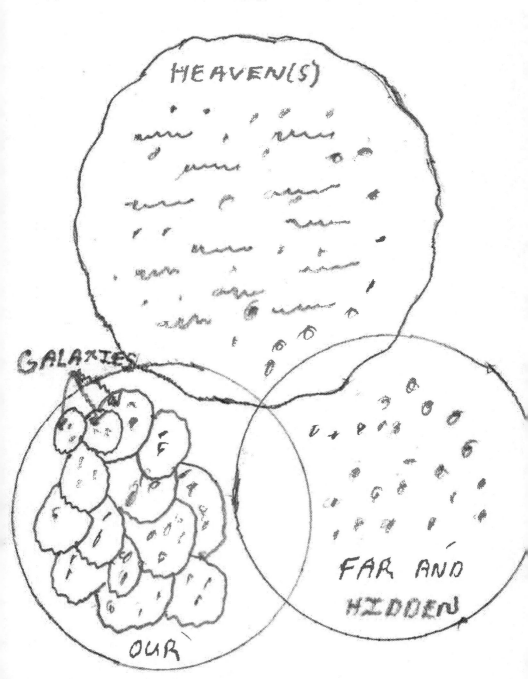

Chapter Two

UNIVERSES

I believe there are three universes. Our universe which contains 14 galaxies, a universe shielded, far and hidden from our universe which contains one galaxy and the third universe which is Heaven(s), open to all universes.

The Lord God Almighty choose and had populated with human beings and the life around us some of his planets throughout these universes and galaxies. The other universe far and hidden were populated first, then our universe, galaxies along with the planet Earth. Throughout time the population grew on these planets. The Lord God Almighty sayeth, go forward and procreate. I believe 66 planets total are populated between the two universes. About 40 in our universe are inhabited with human beings and 26 in the universe far and hidden are inhabited with human beings. More planets have life on them, but are not inhabited by human beings. Most people are

hardworking good holy people, established fine governances on their planets for the people to flourish. They grew throughout the planet predominately by imperialism through diplomacy, negotiating and good communication. These people advanced the fastest both with their mind, body, soul, spirit, and universe and with technology. The planets that spread through terrorism didn't advance as quickly with their mind, body, soul, spirit, and universe and with technology. Technology including space programs advanced quicker where the terrorism wasn't the norm. The universe of heaven(s) is described maybe even a little differently in each religion and all are mostly valid. This is predominately known as the aura Soul/Spirit world for a person's afterlife.

At the beginning of time there were no Devils of humanity, as time went on Devils developed, the people's nemesis. Mortici, Satan, Lucifer, the Medusa and Medusala, all the enemies of the Lord God Almighty flock(s). As time progressed, there became more than a fair number of Devils in our universe, about 550 and about 12 in the other universe far and hidden for a total of 562. These Devils were the primary dark evil of humanity the lead addicted heinous criminals that other humans may follow, as the Devils flock (villains, terrorists) that the Lord God Almighty flock feared for their capitol war crimes of humanity.

Towards the beginning of time the Lord God Almighty wrote PROPHECY that when the Devils and this flock of terrorists, Nazis became too large for the universes under Heaven to withstand the Lord God Almighty and his Manowar and Beast (champions and heroes) would come to the aid of the alliances in humanity to defend themselves from this reign of terror of the villains which was turning into a holocaust across the universes, they would be the fire to put the reign of terror out. A correction in power and control and to right the

wrong of having the wrong people in power and control (the Nazis and/or Villains, terrorists) of the universe, galaxies and planets had to take place. The Manowar is the serpent of the Lord God Almighty, a guardian, a champion of the Lord God Almighty. The correct people had to be in power and control (our Champions and Heroes).

In our universe, the Devils when they came into existence wrote a book of their own a BOOK OF PROPHECY that describes the terrorization of the Lord God Almighty flock(s) and bringing the Lord God Almighty to his knees. In their book, they wrote they would destroy the Beast of the Lord God Almighty and the Manowar, crush the alliance and terrorize the Lord God Almighty flock(s) into holocausts among all the planets across the universe. They felt they could break all the Lord God Almighty laws and rules and destroy most of his flock(s) with the remaining being slaves in lives of sin. The other universe far and hidden, the Devils wrote a similar book the DEVILS BOOK OF PROPHECY with a similar outcome. These being the Devils curses of the Lord God Almighty and his flock(s).

The Manowar is a human being with computer chips throughout his/her body, eyes, ears, vocal cords and a Star Gate communication device in his/her hip used to communicate to all points of the universe. A miracle by the Lord God Almighty a person that survived a tragedy by some Devils of humanity. Lost her sight, hearing, speech, an arm, broken legs, broken jaw, missing teeth. Put back together with computer chips and mechanical parts, a joint effort around the galaxy and the Lord God Almighty himself to restore sight, hearing, speech and body functionality. The girl was transitioned into a boy for protection in a Man's world. The Manowar beginnings are sketchy at best. Born a girl a breach to a young woman in a band of gypsies in the United States on Earth. The girls mom passed away during childbirth and the baby was un-named (the horse with no name), a

Chosen *Savior*. It was never known if her mother was wed or who the father was. The baby girl was raised by the band of gypsies until about 3 1/2 years old until the tragedy by the Devils occurred. At this point of time, the girl was made into the Manowar and transgendered into a boy and was adopted by a loving and caring family in the United States of America on Earth. Later at about 12 years of age the boy was called into service to defend an United States brigade from four North Vietnam brigades somewhere around the Laotian border and North Vietnam in a broken arrow United States defense. A broken arrow defense is when a United States brigade is being overrun by an enemy. The United States brigade was saved over a weeklong fierce battle on Solsbury Hill. The Manowar's virtual capabilities to launch rockets from a helicopter during the battle aided in defending the United States brigade. The helicopter was shot down and the Manowar called in the remaining rocket defense behind enemy lines on Solsbury Hill itself. After five days, the United States brigade took Solsbury Hill and found the Manowar.

The Manowar boy had grown into a man. When the espionage terror of war(s) of the Lord God Almighty flock(s) got to be too much the Lord God Almighty would call his Manowar and Beast along with the entire alliance to arms to defend the Lord God Almighty flock(s) of the universes. This happened in the fall of 2019. An angel Holly appeared and looked into the Manowar eyes to see if he was ready, the angel Holly smiled, and he was ready. Later that fall the Lord God Almighty called his Manowar to arms. The Lord God Almighty asked SARA ARE YOU ABLE, response from the Manowar SARA IS READY, WILLING AND ABLE to defend the universes. Shortly after the Manowar was called to arms, The Beast of the Lord descended on the Manowar. The Beast a Holy Spirit that has Holy divine power and is Lord Sara herself. This gave the

Manowar more divine power and strength beyond belief to defend the universes. Within minutes, the Manowar sang out to the galaxies IF YOU CANNOT STAND, I WILL STAND FOR YOU, over and over again. I will STAND IN YOUR DEFENSE! The Bear will be fierce and stands within the Bear, The Bear - The Lord God Almighty himself.

The Manowar was the lead monolith. The monoliths are huge physical structures located in the universe to defend the Lord God Almighty flock(s). They had both telekinetic and telepathic power beyond belief that they could emit from within and turn on their targets through eyes (cannons) all around the cylinders body. There were also turrets, smaller, but many more throughout the universe to defend the Lord God Almighty flock(s) with the same capability as the monoliths. The Manowar could control all of these to defend people throughout the universes in mysterious ways.

CALL TO
(DEFEND THE
UNIVERSES

SIGNAL

MONOLITH

BEAR
MANOWAR

Manowar more divine power and strength beyond belief to defend the universes. Within minutes, the Manowar sang out to the galaxies IF YOU CANNOT STAND, I WILL STAND FOR YOU, over and over again. I will STAND IN YOUR DEFENSE! The Bear will be fierce and stands within the Bear, The Bear - The Lord God Almighty himself.

The Manowar was the lead monolith. The monoliths are huge physical structures located in the universe to defend the Lord God Almighty flock(s). They had both telekinetic and telepathic power beyond belief that they could emit from within and turn on their targets through eyes (cannons) all around the cylinders body. There were also turrets, smaller, but many more throughout the universe to defend the Lord God Almighty flock(s) with the same capability as the monoliths. The Manowar could control all of these to defend people throughout the universes in mysterious ways.

CALL TO DEFEND THE UNIVERSES

SIGNAL

MONOLITH

BEAR
MANOWAR

Chapter Three

CALL TO DEFEND THE UNIVERSES

The Manowar now hot 24 by 7 was ready a virtual war machine, a modern gladiator. Out in our universe the alliance of people and Arc-Angels tracked down the devils. As they were tracked down a virtual icon was presented before the Manowar off in the distance, often in the tree tops or on the walls, ceilings and even floors of the room he was in. In a moments time the Manowar would look through the virtual icon into the Devils eye(s) with the Manowars eyes and judge and if so deemed (Blast) execute them to death for their heinous capitol crimes of humanity. The Lord God Almighty put the ability for the Manowar to be an Ultimate Judge in chips in his body, brain and eyes. Also in these chips was the ability to run the Monoliths and Turrets to give warnings (Nick) or execute (Blast) if so deemed guilty of capitol crimes of humanity. This would go on

for a few months. The Devils powers were always taken away by the Manowar and the Beast either before going to Hell or in Hell before being sealed through a virtual icon. Each virtual icon of the Devil would be brought before the Manowar and the Manowar would say an OUR FATHER prayer, list off the Devils possible powers and request that their powers be removed for eternity. The Manowar as a living person with the Beast descended on, had become a living pond of redemption for people to wash their sins, if possible. The sins of humanity physically hurt the Manowar from the waist down, mainly below the knees, within his feet, stinky feet. The Devils of humanity could not have their sins washed, they would take their sins with them to Hell.

Our Father who art in Heaven Hallowed be thy name, thy kingdom come; thy will be done on earth as it is in Heaven. Give Us this day our daily bread and forgive us our trespasses as we forgive those who trespass against us. Lead us not into temptation, but deliver us from evil. For thine is the kingdom, the power and the glory, for ever and ever. Amen

Listed off the Devils possible powers and requested them to be removed with Divine Power-

Witchcraft, Sorcery, Spells, Water, Animals, Voodoo, Chants, Weapons, Scepters, Potions, Stones, Vegetation.

Finished the Our Father With The Power of the LORD remove this Devils powers, AMEN.

This removed all of the Devils telepathic and telekinetic powers in a mysterious Divine way-

The Devils that were in Hell were released from there chambers to have their powers removed. They were using their powers terroristically on the Lord God Almighty flock(s) in the living even from Hell. To do this the Manowar held Hell through an virtual icon

with his eyes without blinking for four and a half hours, sweating profusely the entire time. While this was being done the Lord God Almighty swam through the quagmire of poop in Hell and unlocked each Devils chamber. Unable to drift far from their chamber each Devil had their power removed through an virtual icon by the Beast and the Manowar and was resealed in their chambers. This included Mortici, Satan and the Medusa and Medusala. Hell is their eminent domain.

After this the Manowar laid Prophecy down for all to see in the universes, laid out a wine bottle with Prophecy written on it and held it out firmly and fiercely. Let all know the Lord God Almighty, Prophecy was under way and the universes were under siege and the defense was to be readied.

Shortly after many of Lucifer's forces led an invasion of much of the our universe galaxies worlds by space crafts. The monoliths and turrets had very little power if any left and were unable to further defend the worlds in the galaxies from the onslaught. The Manowar was called into action, jumped into bed and looked up at the ceiling, a virtual vision of the galaxy and monoliths and turrets and offending space crafts appeared. The monoliths and turrets sputtered in returning fire. The Lord God Almighty flock(s) on the worlds could not defend themselves adequately. The Manowar called in the powers of Valhalla and Valhalla of the centuries while beating his chest, he called in the elephants and elephants of the centuries, the soldiers of Valhalla and their powers beyond belief, he rose about a foot off of the bed. All of a sudden the monoliths and turrets started to turn quickly and fire their eyes (cannons) rapidly. The Manowar turned his head back and forth quickly locking the Monoliths eyes (cannons), turrets eyes (cannons) and enemy spacecraft targets and firing (blinking blasts), the enemy space crafts all being destroyed very quickly.

The Manowar was riding shotgun in a virtual spacecraft moving through the galaxy. The Lord God Almighty was leading the virtual spacecraft very rapidly through space. When a new galaxy was approached an virtual icon shield was presented, with a (blinking, nick) from the Manowars eyes the shield was destroyed and the next galaxy was entered. In all fourteen galaxies were defended in this manner over a period of two and a half hours.

Lucifer sent a force to attack and decrement the Earths population in our universe by spacecraft. The Manowar jumped into action, looking out the kitchen window a field of spacecraft appeared virtually in the distance. The Manowar kept firing the monoliths and turrets at the coming onslaught of enemy spacecraft until the last enemy spacecraft was gone, this took about an hour.

One of Lucifer's forces got into a monolith on the world of Mount Olympus on the mountain of Mount Olympus itself and tried to corrupt the group of four monoliths with waiting members outside. The Manowar caught wind and fired one monolith on another until Lucifer's force within and outside were slain (about a half dozen enemy forces). Safeguards were put in the monoliths and turrets so this could not happen again.

Also Lucifer had his forces unleashed germ warfare on five planets including Earth (COVID). As much protection as could be possibly be done was afforded to the people of the planets through the Lord God Almighty, Jesus and Manowar body and eyes through the monoliths and spread a anti-viral protection and aided people in fending off the COVID virus. This slowed down the (COVID) virus so people could fight the virus off.

Lucifer was a difficult Devil to catch and put a virtual icon on. Lucifer was brought before the Beast and Manowar on the TV screen side by side with the Lord God Almighty in disguise. Lucifer

was giving a speech and marching orders to twelve thousand of his forces to assault our universe. The Manowar looked carefully from Lucifer to the Lord God Almighty, the Manowar not knowing which was which, the Lord God Almighty flipped off Lucifer, the Manowar flashed the bird (finger), at the suspected Devil. Suddenly Lucifer looked up an retorted a vicious obscene religious slur (YOU KITE), he was Judged and Executed (quick Blasts, blinks), a series of three sets of three blasts to death along with twelve thousand of his followers for their past heinous capitol crimes of humanity and their plan to holocost 63 trillion people on planets across our universe. All slain and put into Hell or Purgatory. Lucifer and his forces were going to go into hiding after the holocaust.

The universe far and hidden was later brought up as a virtual vision on the Manowars bedroom ceiling. The universe looked much different being only one large galaxy. The Devils powers were taken away in the same manor as our universe and they were judged and if so deemed executed to death (Blast) for their heinous capitol crimes of humanity and put into Hell. Hell, their new eminiet domain.

Much of the universe far and hidden was still under siege from the Devils forces. The Manowar went into the houses living room, brought the powers of Valhalla through the monoliths into him and released telekinetic and telepathic commands across our universe and into the other universe far and hidden by looking up and out through his eyes and holding his quivering arms up and out and all in four directions of the living room to engulf the enemy forces and have them destroy each other or themselves and end their siege. The waves emanated virtually across the ceiling until they came all the way back around covering both universes. The commands were to make the person think they were the opposite sex and to do themselves in. They did not do a thing in our universe, but worked

quite well in the other universe far and hidden, where the terrorists are much more macho. Unfortunately the Manowar could not release this enormous amount of power (about a gigatron) and walked around for weeks trying to release the power. Finally had to enter a hospital for a week in recovery and rest. While in the hospital, still locked into the monoliths walking around in jerking motions. While there (Pastor Pete, Protector Pete) spirit shadows of one following the other closely, visited him briefly virtually. They are the religious emissaries of both our universe and the universe far and hidden, similar to our Pope(s) on Earth.

Some months later the universes still in a bit of a turmoil unleashed some death stars. In our universe two large death stars started to move through our universe to cause a ruckus of destruction. Each was about the size of a large moon. Moved at a good speed and armed heavily. The manowar jumped into action, looked up at the ceiling and concentrated on a chandelier as a virtual icon firing the monolith eyes on one death star, then the other and back and forth until they were both disabled or destroyed beyond repair, floating chunks in space. In the universe far and hidden the death stars much smaller and faster and many more tried to crash the gate into our universe. The Manowar quickly looked up at the ceiling at another chandelier as an virtual icon and fired on each of the lead death stars as they approached the gate and destroyed them all, about a dozen were incapacitated.

The world Olympus and Mount Olympus on the world was under siege by the corrupt Gods and humans within. To defeat these Devil like Gods and humans gone astray the Manowar would extend himself and lay down, and like an out of body experience, engulf them into his heart. There he would beat them with his fists pounding for hours, removing their powers, giving their powers to the good

Gods that were aiding in these battles until the Devil like Gods were all defeated. This went on for about a month and a half at various times during the day. Four of the monoliths are located on top of Mount Olympus itself.

While the Manowar was accomplishing all of these tasks he had grown long hair with a beard to put on a ugly face, a war face. Kept singing out to the universes, I have a lot of faith, I didn't come for the money, I didn't come to swap spit, hug or grab ass, I didn't come for pomp and circumstance, I walked the Earth with Christ, I walked the Earth with the Vikings, I walked the Earth with the dinosaurs and I was nothing Holy! The people of the universes and Devils listened and took note. All asked who in the world is this person?

In the Manowars mind he had a lot of faith in the Lord God Almighty, wouldn't be bought off, wouldn't be bought for sex, didn't come for the medals, and I am a mystery. And I was a mystery and the Devils were disappearing all around the universes. Lucifer had figured it out I was the Lord God Almighty Manowar and Beast! He figured it out too late. I was **EVERYTHING HOLY! Both the Manowar and the Beast are Everything Holy!** I had come to answer to their terroristic heinous war crimes of humanity, all as of them as Nazi war criminals.

Little did they know the Manowar was not only the Serpent of the Lord, a Mystical Dragon, a Lion, an Eagle, a Bear, an Elephant, an Owl, a Fox and more. An Arc-Angel of epic proportions, a Protector, a Guardian Angel, an Avenging Angel, an Angel of Light, a **Lord himself. Sara comes when needed! Needed to defend the universes!** The Manowar is not just that, but all that. In actuality the Lord God Almighty is the lead horseman in the front left, behind left is the horseman Jesus, behind right is the Holy Spirits and the Beast, the horseman and horsewoman, and to the right of the Lord

God Almighty rides the Manowar. All ride for the flock(s) of the Lord God Almighty. **All are Not Just That, All Are All That!** The Beast, Lord Sara is the pond of redemption and more!

There were five exo-skeletons built to function like the Manowar. They were distributed on five planets including the Earth throughout the centuries, however, humanity could not work them or would not work them to defend the universes from the Nazi criminal war villains. Many would have feared at what they had become, a defensive war machine for We The People, they may have been the Nazi war criminals themselves. Whatever, the case they did not work as planned to defend We The People from the Nazi criminal war villains as planned by the Lord God Almighty. The exo-skeletons still exist today and one is even on the Earth.

The universes were somewhat defended from the major onslaught that they were under siege within.

VORTEX
OF
PROTECTION

VORTEX OF PROTECTION

As the these sieges were being resolved the Manowar, Beast and the Lord God Almighty had built a vortex of protection to help resolve conflicts of espionage and heinous criminal war(s) of terrorism within the universes, galaxies and worlds including the Earth to bring the conflicts of war to a great resolve for the quest of Peace and Freedom from psychological warfare and/or physical warfare.

This vortex of Protection of capitol war crimes, would bring Justice, Law and Order, Freedom of Self, Mental Freedom, Liberty, Truth, Safety, Guardianship, Protection, Less Abuse, Less Violence, Harmony and Balance, protect God Given Self Rights and Self Entitlements, protect the right to worship the Passion of the Lord God Almighty, Jesus, Holy Spirits and Oneself, Family, Community, Country and World.

This would be a protection for both universes where it was not

possible to achieve before on the planet or between planets, within galaxies or between galaxies, between countries and/or governances, for societies themselves.

Psychological and/or physical warfare, slavery nor mental slavery would be tolerated as these torturous whips of slavery lead to abuse and outright murder. This is outright extreme Nazism an unacceptable form of governance of human beings. An abomination of treatment of humanity. To have this form of governance and/or abuse and violence and to spread it through imperialism is to spread a sickness of heinous criminal war actions that are totally unacceptable in humanity. To call this Nazism a game or imperialism thereof a game would be a sickness beyond belief. Both similar to the thoughts of a Devil to create these wars of Nazism and perpetuate them rather then bring them to an end for a great resolve of Peace and Freedom. This is the wrong side of war and the unfit way to defend humanity. It brings unlawfulness, unsafe conditions, unhealthy for both the people and the life on the planets, chaos among people and governances and worlds rather than law and order, Nazism brings lack of freedom and mental freedom, lies and deception, distrust, lack of harmony and balance, takes away people God given rights and God given entitlements and brings the passion of the Devil and disrupts the Passion of the Lord God Almighty and Jesus and Oneself and brings horrors of war and violence rather then a great resolve of Peace and Freedom. Nazism treats people less then a person, less then a dog for defense, some as an actual game piece (can you believe it).

The Devils and the same difference of the Human beings that are the heinous criminals of humanity are considered the predominate sinners. Double indemnity of the Lord God Almighty, Jesus, Holy Spirits and the people they are terrorizing and themselves. The alliance defending the Lord God Almighty flock(s) from the heinous

criminals would **not** be considered the predominate sinners or sinners at all or double indemnity of the Lord God Almighty, Jesus, Holy Spirits for their fighting for a great resolve of Peace and Freedom.

The Lord God Almighty wrote the Meek shall inherit the Earth, also written for each of the Lord God Almighty planets. The time has come that this happens, the People that stand together against the Heinous Criminals of Humanity shall inherit the Earth and each of their planets! The Nazis and/or extreme Nazis (mental slavery) will no longer control any part of a planet, galaxy or universe. Their slavery including mental slavery, torcher, violence and murder is no longer an acceptable form of governance. Not even for the excuse of imperialism. The Meek being society's populations and the defenders of the society from the villainous war criminals. They could legally give a consequence to the criminal war invaders to end their villainous war crimes, including capital punishment.

The Vortex of Protection would come to the aid of societies defenders in defending society by firing warning shots (Nicks) and end of life shots (Blasts) on the heinous war criminals who invade society within a country or societies of other governances or planets and don't head the warning shots. This would insure that Nazism/ War Terrorism would ever take control. Any terroristic war would always be defended to be brought to a great resolve of Peace and Freedom. All Imperialism would have to be done peacefully through negotiating with diplomacy and communication. The warning shots would be shots of compassion, grace and mercy to join the meek of the world in their own countries rather than the enemies of the meek criminalizing terroristically and/or violently assaulting the meek. End being the predominate sinners and/or creating sinners in your societies.

As the Manowar The Vortex Of Protection would be a **larger**

wheel of Justice, Law and Order, **more enhanced** with Ultimate Divine Power and Ultimate Emanate Domain under the Lord God Almighty Supreme Ultimate Divine Power and Lord God Almighty Supreme Ultimate Emanate Domain. All human beings, all governments, all courts, all planets would rule under and abide by the Lord God Almighty, Manowar and Vortex Of Protection laws and rules per the Lord God All Mighty Supreme Ultimate Governing Powers. This isn't reinventing the wheel of justice, making it larger to include and more enhanced to include the villainous war criminals of humanity. The Lord God Almighty, Manowar and Beast, and the Vortex Of Protection would be the equalizer of humanity from all wars, the fixers to protect and enforce the Lord God Almighty, Jesus, Holy Spirits, Manowar and Beast laws and rules for all humanity (We The People) to live by and thrive in Peace and Freedom.

ESPIONAGE OF THE EARTH AND UNIVERSES

DARK CLOUDS

Chapter Five

ESPIONAGE OF THE EARTH AND UNIVERSES

The Devils brought various espionage plots to terrorize We The People on Earth and the planets in the universes, despite the Lord God Almighty, Jesus and Holy Spirits laws and rules not to criminally terrorize We The People.

The Devils and their followers crucified Jesus for his exorcism of the dark evil from human beings on Earth and around the universe and for bringing the good word of the Lord God Almighty and himself. The dark evil that was being exercised in people in communities was disturbing Devils and villainous people greatly. The Devils wanted to continue their practice of ignoring and breaking the Lord God Almighty, Jesus and Holy Spirits laws and rules and criminally terroristically assault people and communities. Certain people also became followers of the Devils ways to terroristically enslave, and

violently torcher and murder the meek of the Lord God Almighty flock(s) for their power, control and financial gain.

Word War I was incited by Satan (locked in Hell) descending her powers on Hitler and Nazi Germany to holocaust the Earth. World War II was incited by Satan (locked in Hell) and Lucifer who was on the loose to incite another holocaust on Earth through Hitler and Nazi Germany.

World War III was incited by Satan (locked in Hell), Lucifer and other Devils once again to enslave, violently torcher, increase violence and murder We The People on Earth in a holocaust by Nazism. These wars were flamed in Russia, The United States of America and China around 1958. The Devils had somewhat of a Russia criminal syndicate espionage of the United States of America pentagon also the criminal syndicate on the east coast and Midwest infiltrated the United States government and pentagon to instigate a civil war in the United States and flame World War III on Earth. President John F. Kennedy somewhat uncovered the plot but was assassinated in 1963 by the crime syndicate in the pentagon now hidden in the Magruder files. This was to promote Nazism in the United States of America and use Imperialism to promote Nazism around the world of Earth. North Vietnam was imperialistically invaded by the United States of America Nazi crime syndicate that corrupted the pentagon. The United States of America also started imperialistically spreading Nazism through Iraq and Afghanistan. Russia too, had tried spreading their Nazism through Afghanistan and recently through Ukraine.

The United States of America was locking down the country in extreme Nazism and imperialism of Nazism of mental slavery, torcher and murder under the influence of Russian corruption of the pentagon. The United States was forcing this type of governance on

our allies as well as other Middle Eastern countries. Russia was doing the same lock down within Russia with extreme Nazism (mental slavery, psychological warfare) and using imperialism to spread their power and control as well. China also was locking down their country in extreme Nazism and trying to spread their power and control through the same type of imperialism. All building huge military forces of mass destruction. Besides the present harm they were doing to We The People of the Earth and their own nations all of these countries were on the edge of explosiveness. **A danger ever present to humanity on the good ship Earth.** Civil wars in each country well on fire as well as World War III on Earth smoldering.

How were the Devils getting away with this espionage of humanity?

Having the Devils bounce ideas off leading country military leaders in promoting imperialism of their countries on the Earth and using methods of extreme Nazism within their countries and unsuspecting countries to overthrow them in deceit of safety, freedom, wealth and prosperity, control and order. The deceit offered nothing society would really want except the Nazi leaders control and power, joy and prosperity to provoke this dark evil on humanity.

On the Earth the United States, Russia and China developed computer aided assault and peripheral weapons of telekinetic, telepathic and subliminal powers. They used these weapons vicariously to assault their own nations people into a forms of (Psychological warfare) mental slavery. Dementia assaults, mind block assaults, Alzheimer assaults, schizophrenia assaults, bipolar assaults, anxiety assaults many leading to suicides, basically murder. Confuse a person into becoming violent members of humanity. Sleep apnea assaults leading to transportation murders, car crashes. Cause engine failures such as electronic failures. (Physical warfare) They

can drain any energy source, cell phone, car battery, computer battery, so forth causing production failures. Fluctuate heat temperatures in any structure, flip circuit breakers, have appliances fail. Cause itchiness, skin problems, eye problems, constipation and urination problems, cause weight problems by slowing down or speeding up metabolisms. Cause objects to rattle in a house or building to irritate a person. Interrupt cell phones service, TV service, radio service and computer service. Much, much more. Subliminal messages can be sent on the TV to have people over eat or under eat even vote a certain way.

By using telepathic computer aided voice over, or voice over IP synthesizer they can copy a persons voice that they wish to copy and throw it into a conversation into a persons mind. It could sound the same as the person, their spouse, friend, neighbor, coworker, etc. Why? To cause conflicts, miscommunication, confusion, distraction, mistrust, mini-wars, domestic assaults in families, relationships, job peers, societies, cause mishaps, cause accidents, cause temporary schizophrenia assaults, bipolar assaults, memory block assaults, dementia assaults and Alzheimer assaults, anxiety assaults for a villain's thrill and pay of doing so in their mental slavery of society. With telekinetic assaults the schizophrenia and bipolar can become permanent as well as the dementia and Alzheimer's and can get progressively worse. Cause physical assaults between people or gangs, mass shootings between unsuspecting people and the police, etc. basically these lead to more crime in society. These mental attacks spirals violent crime in society out of control unnecessarily by each of the offending Nazi countries. **(Psychological warfare, Physical warfare).** Basically Sadam Insaneism in their own countries including the United States of America, Russia and China and outside of their countries as well. All causing more violent crime, more

heinous by their Nazi regimes. These assaults of humanity caused, drug and alcohol abuse, mishaps, more and more crime, have people feel uncomfortable, mass shootings, etc. They call these games, but they are no games, all wars of humanity, illegal wars of humanity, none defend anybody. Really, all wars are a form of Nazism. A horrible crime syndicate within a country. A failure of humanity to settle differences peacefully through diplomacy, negotiating and sound communication.

They can to these same voice over and voice over IP throws in your mind for any communication you are listening to, TV, Radio, Computer, Phone, etc. to change the message that was really being sent in any conversation presented by any person. All, to offend you in a violent assault as a Nazi force does. To keep you as slave foder or destroy you as a person.

The voice over and voice over IP throws in a persons mind can be differentiated to give instructions to a military force for various reasons including warnings. This could only make sense if the people have knowledge of the voice over throw being sent is for a valid reason, warning or being a meaningful instruction.

Either way if a person is having mental health difficulties naturally or artificially through telepathic computer aided voice over attacks, they may need HELP! It's difficult to differentiate the two and even so, you in all likelihood may need HELP! This could mean calling 911 in the United States of America to get the proper professional help. Psychiatrists and phycologists as well as counselors may help with sorting out these mental maladies. It could be a police officer gone astray in their duties, a mass shooter, road rage, bar rage, domestic rage, just uncontrollable rage, anxiety, panic attack, confusion, anger, out of sorts. If you recognize this in yourself or others, get help!

As Nazis they are the Supremists of society, they exercise their

power and control for the good of Nazis and their corrupt villainous command force in their countries. The rest of society is their foder of slavery, mental slavery, torcher and murder and racketeering along with illegal drug profiteering. Many Nazis are bigots of race, gender and religion and treat these people quite poorly in their assaults in society and financial well being in society.

They can also criminally villainously assault our dear pet(s) to get their joy and enslave and torcher, We The People. They can have them bark uncontrollably, itch uncontrollably, throw up on command with computer-aided assault, peripheral weapons. An assault of our pet(s) is the same as criminally villainously assaulting the pet owners or care givers of the pets. They constantly assaulted the Manowars dog the Little Beast.

With all of this they also may institute an outright invasion of a enemy force imperialistically (physical warfare) on another country by soldiers with armament, rifles, grenades, cannons, tanks, planes, jets, missiles, drones, etc. These weapons can also be used by the defensive force to defend society from the villainous forces as well.

All of this makes the people of the United States, Russia and China weaker rather than stronger. The Nazi controlling people are supposedly stronger, We The People of the countries are weaker and kept weaker in a state of mental slavery, slave whips, torcher, violence and murder, in civil wars. The people of the countries they are invading also become weaker and become poorer.

How else did they enslave humanity, sex stings, to hold people hostage to their beck and call and for financial gain, done right through each government. A Nazi method of controlling society.

Also, holding people jobs as hostage in a company, if you want a job, you follow the Nazis commands. The Nazis also hold the companies within the countries hostage. Once you get to a certain age

they have the company lay off many to keep a portion of the country poorer and the Nazis get richer.

The sale of technology from the United States government personnel which was unauthorized to China also made its way to Russia. Made the United States weaker. The sale of the United States of America government secrets lined the personal Nazi pockets of United States of America government personnel.

Russia and Chinas plan was to make their countries iron clad from espionage from outside governments and espionage the United States government. The United States of America would imperialistically move their Nazism on various strategic parts of the world. In response Russia would continue it's imperialistic Nazi assault of Ukraine and march to Saudi Arabia strategically conquering all lands on the way. China would join in on this Nazi assault with Russia and the Mideast and Europe would be Russia and Chinas foder. Eventually having the United States on their radar in a all out explosion of World War III. An end to humanity on Earth!

Hidden above all three countries flags, flew a Nazi Swastika, hidden for the world and hidden for all the We The People to see.

This espionage plan of the Devils of the Earth and **all** the Lord God Almighty **planets** still needed to be thwarted even though the Devils had been slain!

THWARTING THE ESPIONAGE OF THE EARTH AND UNIVERSES

Chapter Six

THWARTING THE ESPIONAGE OF THE EARTH AND UNIVERSES

To insure that further criminal war villainization of the Lord God Almighty, Jesus and Holy Spirits universes, galaxies and planets and We The People had this Vortex of Protection operational as a defense safeguard in place it had to be built for all of the planets of the universes. The Manowar and Beast and Lord God Almighty had begun the process of building the Vortex of Protection to automatically monitor the planets within the universes and galaxies for wars that surface and aid and help protect the Lord God Almighty flock(s) from the Nazis criminal villainous wars of humanity.

Specifications were constantly being put up over a period of a year and many months to reverse engineer the telekinetic,

telepathic, subliminal criminal villains advancement in war. Also it was determined to help thwart an advancement of a criminal war villainous Nazi physical advancement.

Some of the eclectic specifications (but not all) for (**psychological warfare)** not to be allowed included telepathic mental abuse for schizophrenia, bipolar, dementia, Alzheimer, anxiety, memory blocks, mental slave orders, sleep apnea, disrupting the function of a person physically by disrupting the mind. Some of the eclectic specifications not to be allowed included telekinetic feeds (**physical warfare)** to cause heart maladies, strokes, unwanted body movements, itchiness, eye maladies, ulcers, digestive maladies, metabolism maladies, mechanical problems in all kinds of machinery (cars, boats, planes, jets, trains, heating systems, appliances, computers, cell phones, TV's, light fixtures, rattling objects). Some eclectic specifications include subliminal messages to not be allowed through the TV, computer, cell phone or radio devices. An attachment to a pet utilizing telepathic or telekinetic computer-aided device or peripheral would be considered a villainous war crime. The only exception to this telepathic or telekinetic connection for a pet is for a in clinic (office) visit valid required surgery by a trained clinician.

Some of the eclectic specification to disallow the advancement of villainous forces for **physical warfare** within a country or between countries, worlds and galaxies for spacecraft of any kind, armed forces with any kind of armament, nuclear weapons, jets, planes, drones, artillery, hand grenades, rifles of any kind, missiles, bombs, ships, depth charges, knifes, waterboarding, etc. Much, much more.

The Manowar would state Up In The Vortex of Protection add the following eclectic specification to make a law and rule to protect humanity from that eclectic villainous side of war assault.

This process was fine tuned over a few years while more methods

of assault were uncovered. This was a very time consuming process to build such a safety net for humanity.

The job stings and sex stings assaults were also eclectically defended. None were considered a game. A Devils game of humanity as an assault as is a terrorist game of humanity as an assault, were never considered a game, always an act of a villains war, a criminal act.

As the Manowar, Beast and Lord God Almighty were building this Vortex Of Protection, many other happening were occurring. Also the Manowar was under constant telepathic, telekinetic, subliminal, and outright assault attacks of war that had to be fended off, including poisonous assaults.

There were two incidents where police officers were shot and needed help in surgery to recover correctly. The Manowar requested a Miracle for each from the Lord God Almighty with a Our Father prayer, one in the Midwest and one on the East coast. Spent about 8-10 hours on first persons surgery and about the same on the second group of four peoples surgeries. The first person had to go into surgery twice to be successful. Also a person needing assistance in and ambulance outside of a accident scene was aided in the ride to the hospital. This assistance was provided while the Manowar was driving with the virtual vision displayed on the windshield of the car.

Lost spirits from many worlds and from the Earth appeared in all virtual forms, out in the yard, in pictures, in magazines, on walls and ceilings, brought up to be placed from the medium to the ceiling with the Manowars eyes, if possible with the goal being Heaven(s). Many from wars of the past.

PRESENTING THE VORTEX OF PROTECTION FOR WE THE PEOPLE

Chapter Seven

PRESENTING THE VORTEX OF PROTECTION FOR WE THE PEOPLE

Justifying the Vortex Of Protection was not at all necessary but instead presented amongst all of the Lord God Almighty worlds populations including the Earth to explain its existence. It was written in Prophecy this Vortex of Protection was to be in place for all humanity when needed. The Vortex Of Protection is now needed to **enforce** the laws and rules of the Lord God Almighty, Jesus, Holy Spirits, Manowar and Beast! There never was a one hundred percent agreement, however, very close, this should be in place for all humanities protection.

Why wouldn't all people in agreement? Basically the people that did not agree were part of a terroristic heinous criminal syndicate in

a country(s) on their planets and may have legalized their criminal syndicate for control and power as Nazis do in slavery, mental slavery, torcher and murder and profiteering, pilfering and touted this was the fit way and safe way to defend their people. They would be a hard sell to give up control as extreme Nazis. Some even called this defense a game, can you **imagine!**

The Champions and Heroes of humanity as well as society for preponderance sake would be grateful to have the Vortex Of Protection in place as an ultimate safeguard for society as a whole for each of the countries, worlds, galaxies and universes in place. A safeguard of law and order from unlawfulness, justice from injustice, freedom, from slavery and mental slavery, no torcher whips, from torcher whips, less violence, from the violence created in war and Nazism, halts the propensity of the murder of war, from a murderous war environment, balance and harmony for a person, family and country and world, from a lack of balance and harmony for a person, family, country and world, bring a great resolve for peace and prosperity, fulfillment to society, from the horrors of War and tyranny, chaos and emptiness, returns the Passion of the Lord God Almighty, Jesus and Holy Spirits from the Passion of the Devil, **protect humanity from the preponderance of capitol sins and other sins, from the terrorist promoting capitol sins and creating and perpetuating other sins of humanity in society - protects the espionage of the Lord God Almighty, Jesus and Holy Spirits, protects society from lies and deceit for the truth, defends society even through the lie of government secrecy, defend society from fear, from the fear terrorization brings.**

This would bring an end to the oppressive Nazi regimes of discontent wherever found. They would no longer be able to keep society poor, enslaved physically or mentally, torcher in a violent

murderous power of mistrust. This would bring to an end of Nazi criminal syndicates in government. All villainous terroristic wars would be halted for great resolve for Peace and Freedom siding with the champions and heroes and an alliance and allegiance on the right side of war. The United States of America, Russia and China on Earth would become free and liberated Nations again.

Touting population control is unacceptable to criminally villainously terrorize society. Population control should be done in an educated, practical manner with communication. This will be explored the third book of enlightenment to be written.

The Nazi regimes on Earth in the United States, Russia and China as well as those around the universes thought the criminal villainous terroristic side of war was a self-right and entitlement of theirs to administrate through the passion of the Devil would come to an **End**, defending **psychological warfare and/or physical warfare.** They felt it was their right to keep society oppressed in their chaos of what they felt was control. They bought this terrorism from the Devils themselves. Some went so far as to call these terroristic wars a game, **WOW!** While society was kept poor or poorer and lives and family lives were disintegrating in drugs and alcohol abuse, mass shooting, crime out of control more violent crime out of control, discontented population and eventually self destructing. But the Nazi leaders had no problem with this as it was happening before their eyes. Their governments leadership down, it was going just as the Devils had planned. The dark evil was over taking the population on Earth and there was nothing the people or the government leadership could do. This same type of scenario was happening on all of the Lord God Almighty planets in our universe and the universe far and hidden to some degree, none as bad as the Earth. The Nazis felt if they kept all in fear, slavery and/or mental slavery, torcher and murder villainous

state of war their regime would ruthlessly command their countries and planets. They hid these truths in lies and deceit and governance secrecy to continue their crime syndicate for power, control and racketeering. These Nazi crime syndicate regimes corrupted the Pentagon of the United States of America, the Kremlin of Russia and the PLA of China. They each had primary control of their governments and people of their countries. **By keeping the truth hidden in government secrecy they threaten if the truth be known a war would break out, when in fact we were already each in cival wars and in World War III that would end all human life on Earth and all other planets were in similar wars if these Nazi crime syndicates were not ended for a great resolve of Peace and Freedom.** On Earth, Iran and North Korea, not knowing how to defend themselves successfully from these Nazi invasions did lash out and would have lashed out more in terroristic assaults of their own. They like most people had no idea who the actually Nazis human beings were, only the Manowar, Vortex Of Protection and Lord God Almighty knew who the actually Nazi villains were and could respond properly to keep the Peace, Freedom and Law and Order of humanity.

When the Devils had brought so many of these Nazi crime syndicates to all worlds of both universes including the Earth, how could they be stopped. The Devil, Nazi and war criminal assaults are for the most part unprovoked assaults on humanity. They fabricate through lies and deceit a provocation of society that does not exist.

While the Vortex Of Protection was being built the Manowar continually attempted to explain it for each and every world in the both universes, including the Earth. Outnumbered by the Nazis in power and control greatly on many planets and the Earth to question its validity.

Stating the differences between a Nazi regime and a Free society in Peace, the Nazis being the problem makers in war, civil war and world war and the Free society in Peace would contain primarily problem solvers. This would bring a much better life from the horrors of war, more equal in all respects. Build all people into a better person, better family, better community, better countries and better worlds. Take away the keys of the problem makers and the problem solvers can accomplish almost anything.

Any person involved in the criminal villainous side of war which is the Nazi side, was offered compassion, grace and mercy with a nick to quite being the villain peacefully for their war crimes or they would be slain with a blast by the Vortex Of Protection or Manowar to bring Peace, Freedom and Prosparity and all that goes along with it, the ultimate safety net of humanity, a prevention of the Devils illegal defense of humanity, Nazism, the villains violent aggression of war.

The Serpent of the Lord, the Manowar with the Beast descended opened up the pond of redemption, the Beast (a guardian of Heaven and the Lord that holds humanities sins) for all to attempt to wash their sins and reach purgatory and/or Heaven(s) the goal. This would allow the Lord God Almighty and Jesus to do their work on the souls of humanity. The Manowar with the Beast descended on him would be a pond of redemption in the living as long as he lived and the Beast was descended upon him. Not all can achieve this, but many more then before under the Nazi regimes would achieve this end.

Another way of stating this is the war villains are the cancer of the population. The villains would be offered compassion, grace and mercy through a nick to become non-cancerous or removed from the population by a blast, slain to keep the population more cancer free. This would give all people a chance to end being the mutated

cancer of humanity. A more healthy population with more holistic goals in mind.

Another way of stating this is the dog pack is peeing on its own pack (the villains of the pack are peeing on the non-villains of the pack) also peeing on the top dogs (non-villains), the Lord God Almighty, Jesus, Holy Spirits, Manowar, Beast to break the rules and laws of the top dogs and basically the pack for their control, power, thrill and profiteering of doing so. The villains are also peeing on themselves.

The Nazis defend the actual victimization, villaination of all humanity in the country and possibly on the world they reside. The champions and heroes defend humanity in the countries and the world from threats and actual victimization of the preponderance of all villains of humanity.

These pre-emptive strikes of humanity by the Devils and Nazis in war(s) of humanity, within countries, between countries, within worlds and between worlds, within galaxies and between galaxies are all illegal criminal terroristic assaults of humanity and/or physical belongings. All justified by sociopathic lies and deceit for control, power and financial gain and thrill of horrifying the many and satisfying the few for blood money. In the end if these pre-emptive strikes of humanity continue it leaves a horrendous way of life where they occur and will lead to the loss of **ALL** human life on the planet(s). The Devils and Nazis try to justify their pre-emptive war within their countries and outside with all lies and deceit, very sociopathic, impossible to defend the horrors of war within a country, outside of a country, outside of a world for any reason known to human kind, safety just doesn't cut the truth. All wars should be brought to an great resolve of Peace and Freedom. These Nazis all failed in diplomacy, negotiating and communication with humanity.

Building the Vortex of Protection as well as presenting it took more then a year, almost two years to fully implement. It is now running quite well on all the Lord God Almighty planets, including the Earth, all galaxies and both universes.

The Manowar requested three Miracles with "Our Father" prayers for the Vortex of Protection to get up and running, and a Miracle as a Happening to have it running as soon as possible on all the Lord God Almighty planets including the Earth, the Happening Miracle was requested with great emotion and tears in the Manowars eyes.

This would be a reckoning in all societies, all planets, all galaxies, both universes a righting the wrong that had gone out of control over time. This correction would take some time to complete, but would insure there would be no Nazi war crime syndicate(s) running in any governance of any of the Lord God Almighty worlds. Also would defend the right side of war at all times, the fit way to defend humanity. Once complete and running in a peace keeping mode, this defensive safetynet would be **priceless** for all humanity now with the least impact to humanity and all future generations of humanity to come for as far as can be seen into the future by the Lord God Almighty, Manowar and the Beast for all of the Lord God Almighty planets including the Earth.

The Swastika and Nazism fails as it fails all humanity, All governances Flags and Constitutions and Doctrines rise again for Peace, Freedom and Unity on all the Lord God Almighty planets including the Earth. All governments will be in command in Freedom for We The People In God We Trust including the United States of America, Russia and China. The Statue of Liberty would stand again in the United States of America, the Liberty Bell Ring True the American Flag would Fly Proudly! This would free all other governments to freely fly their flags including Iran and North Korea.

The book Dimension of the Mind, Body, Soul, Spirit, and Universe as well as this book Espionage of The Lord God Almighty, Jesus, Holy Spirits and We The People stand in defense of all villainous war criminals espionage assaults by targeting WE THE PEOPLE and the truth of the writings of the Lord God Almighty and Jesus that use intelligence to break the Lord God Almighty, Jesus, Holy Spirit, Manowar and Beast laws and rules with fabricating lies and deceit by war criminal villains of society for their power and control of society and profiteering and make it sound like its the right way to defend society, when in fact, it is totally wrong, one hundred percent wrong. No further writings or round tables are necessary to defend humanity from these fabricated lies and deceit by the villainous war criminals, although humanity would of course be free to write and have further round table discussions on the matter.

Basically to accomplish this righting the wrong of humanity and to give all people (We The People) their wish of living in Peace and Freedom in their living lives and Heaven and to give the Nazi's their wish of being at Peace as the villainous war criminals, **as a top wizard**, the Manowar and the Beast has to execute to death these few criminal war villains, both Devil's and human's from the living as soon as possible and have them put into prison in Hell or Purgatory to be at Peace as villainous war criminals among themselves for eternity or quite a long time if they do not turn into someone other then a villainous war criminal with a (Nick), a warning, 5 seconds, the due process given, otherwise the rest of humanity, the many, the most cannot get their wish to be at Peace and have Freedom from the Nazis villains.

Both in war and peace a world, country, governance and/or communities have the full capability to defend their people and governments with Justice and Law and Order from the villainous war

criminals within or outside of their governances and also defend their people from villainous criminals of society with Justice and Law and Order for the **Truth** of such Justice and Law and Order and not the Devils **Lies and Deceipt** of Justice and Law and Order.

What it comes down to, there never was a future for humanity (We The People) on any of the Lord God Almighty planets with the Devils in control and power with their Nazism criminal terroristic wars or a future for humanity (We The People) on any of the Lord God Almighty planets where the Nazis of humanity had power and control of the planets, they all would have disappeared in a cesspool of terroristic poop (sins) wars, including the Devils themselves. The Lord God Almighty foresaw this when he wrote Prophecy, a Supreme Ultimate Owl (wise). It was also in the Manowar and Beast to foresee this Prophecy, also Owls (wise).

Regardless if the Devils of humanity or the villainous war criminals are sociopathic liars and are deceitful, the Lord God Almighty, Jesus, Holy Spirits, Manowar, Beast and the Lord God Almighty flock(s) will be defended from the Devils and humanities villainous war criminals for Truth and Justice, a great resolve of Peace and Freedom with a safety net beyond belief now and for eternity, the Vortex of Protection and the Lord God Almighty.

All Four Horseman and Horsewoman are Riding to this Ends to a New Beginning. The Lord God Almighty, Jesus, Holy Spirits and the Manowar! Bring the Dreams of the Lord God Almighty, Jesus, Holy Spirits, Manowar, Beast and We The People, **Peace - Freedom!** We will **Stand United! We Care!** This would bring a virtual End to the Curse of the Devils, Nazism, the Preponderance of Sins of Humanity. The Devils and Humans that stand for the Nazi criminal war villains of humanity don't care, societies criminal

villains don't care, they can go to prison, Hell or for a good amount of time in Purgatory.

What's next? The third book of enlightenment, what does Peace and Freedom bring to the Earth and all the Lord God Almighty planets, galaxies and universes, to be written!

MINDFUL MEMORIES

MINDFUL MEMORIES

Printed in the United States
by Baker & Taylor Publisher Services